WHITBY

HISTORY TOUR

HAIR
SHAMPOOING

CUTTING
SINGEING

First published 2018

Amberley Publishing
The Hill, Stroud,
Gloucestershire, GL5 4EP
www.amberley-books.com

Copyright © Robin Cook, 2018
Map contains Ordnance Survey data
© Crown copyright and database
right [2018]

The right of Robin Cook to be
identified as the Author of this work
has been asserted in accordance with
the Copyrights, Designs and Patents
Act 1988.

ISBN 978 1 4456 7985 3 (print)
ISBN 978 1 4456 7986 0 (ebook)

British Library Cataloguing in
Publication Data.
A catalogue record for this book is
available from the British Library.

Origination by Amberley Publishing.
Printed in Great Britain.

INTRODUCTION

This collection of Whitby images helps to explain the enduring appeal of a very special town, not only to its residents, but to the countless visitors both nationally and internationally. It certainly has an enviable history: in early Church developments, world explorer and navigator Captain James Cook, Arctic whaling – particularly the Scoresby family – and in the manufacturing of the famous Whitby jet jewellery. It lies in a very picturesque setting of high cliffs, has an attractive harbour at the mouth of the River Esk, and the ancient abbey ruins dominate the old town. These early photographs mean so much more when enough of the past has been preserved in buildings and streets to enable the later changes to be recognised and better understood.

The invention and development of the photographic camera has significantly helped to promote the deserved reputation of Whitby in the wider community, and the town has been fortunate in having a series of talented and sympathetic practitioners who have championed the attractive features of this ancient settlement. From the early carte de visite images of people like William Stonehouse, George Wallis and John Waller (from the 1860s onwards) to the later major figures of Frank Sutcliffe, John Thomas Ross and the Doran family, and more latterly, for example, Hugh Lambert Smith, John Tindale and the Eglon Shaw family, all of these have served to put Whitby very much 'on the map'.

Scarcely a month goes by without a feature about Whitby appearing on television, starring in tourism surveys, in the national as well as the regional and local newspapers, and in the more contemporary forms of electronic communication.

There are at least seven Whitbys around the world, all of them most likely originating in some form or other from our own dear town, which I am honoured to have as my birthplace. I am also proud to be a life member of the Whitby Literary and Philosophical Society, founded in 1823.

A more comprehensive volume of this material is available in *Whitby Through Time*, also produced by Amberley Publishing.

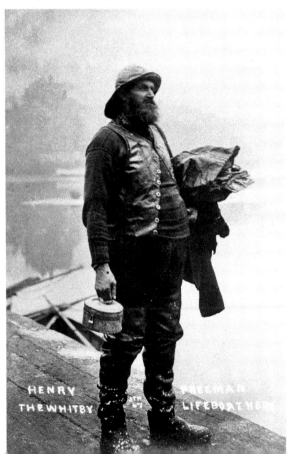

KEY

1. DREDGING THE HARBOUR

A massive early dredging vessel operating in the harbour around 1907 – the old bridge is still in place. This work has been essential in modern times in order to keep the port operational, with silt coming down the River Esk and sand building up at the harbour mouth.

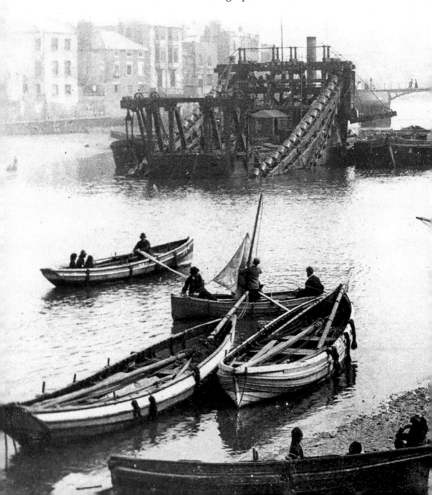

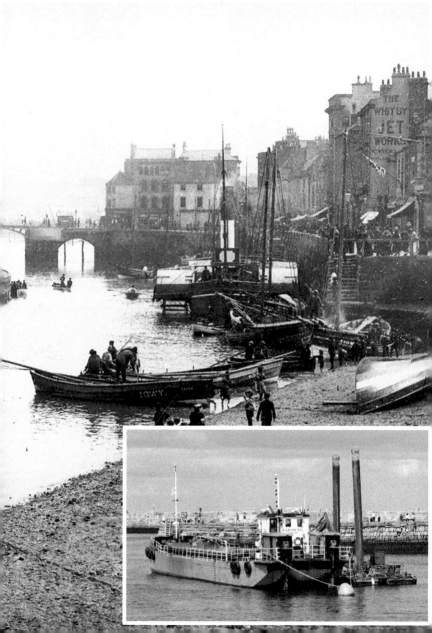

2. CLIMATE CHANGE?

Over the centuries the harbour has been subject to extreme tides and weather. The storm of 12 March 1906 clearly involved a major tidal surge with very big seas, which inundated the area and created a very high water level in the harbour.

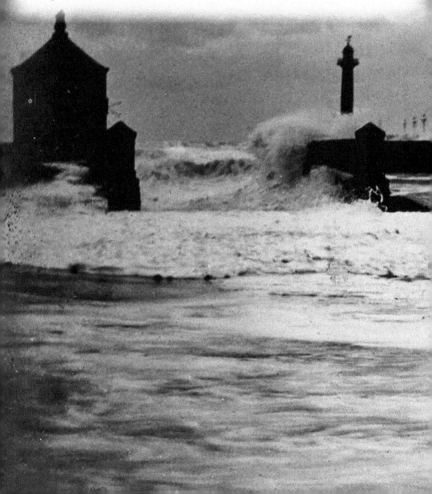

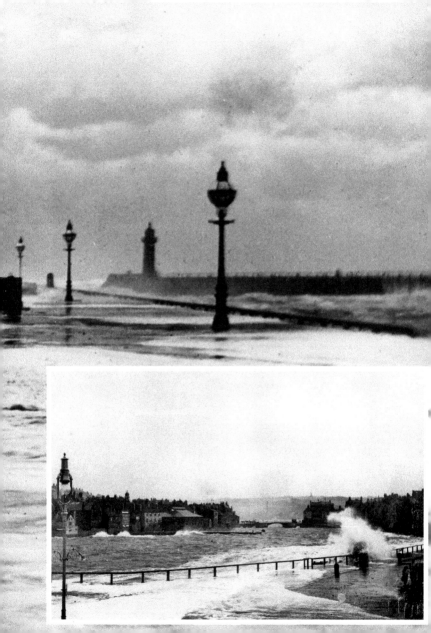

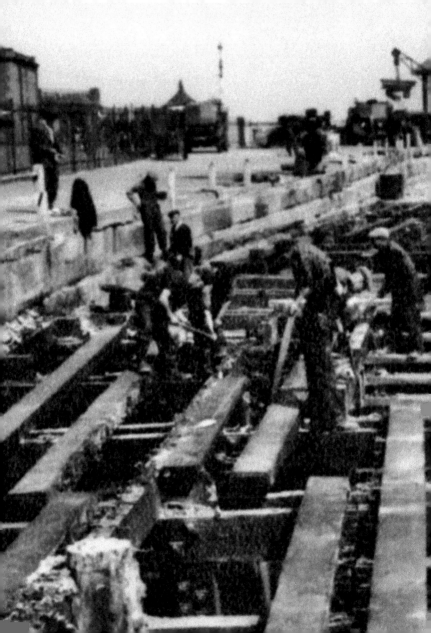

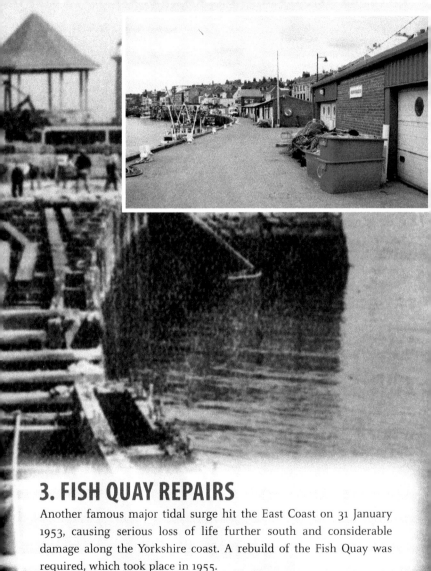

3. FISH QUAY REPAIRS

Another famous major tidal surge hit the East Coast on 31 January 1953, causing serious loss of life further south and considerable damage along the Yorkshire coast. A rebuild of the Fish Quay was required, which took place in 1955.

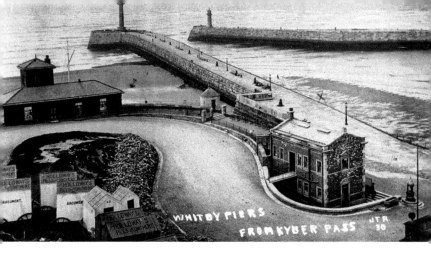

4. THE KHYBER PASS

The Khyber Pass was cut out from the cliff in 1848 to give access from the harbour to the newly developing residential properties on the West Cliff. Bathing machines can be seen drawn up in the left hand corner of the postcard (above), taken around 1905 before the pier extensions were constructed. Unsurprisingly, the motor car now dominates the same scene.

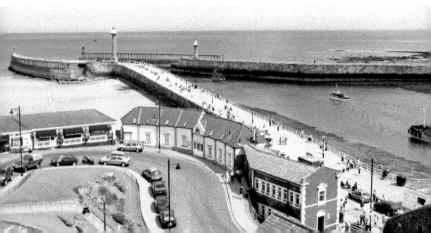

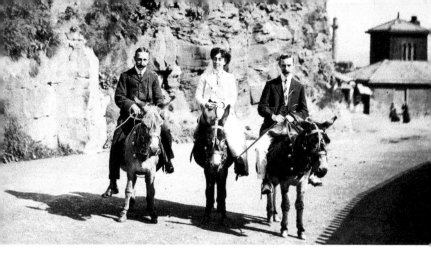

5. METHODS OF TRANSPORT

An overdressed group of adults unkindly ride their donkeys up the Khyber Pass from the harbour area, posing unashamedly for the camera in 1912 (above). The Town Tour bus (below) provides a colourful and more acceptable contemporary alternative at the same site.

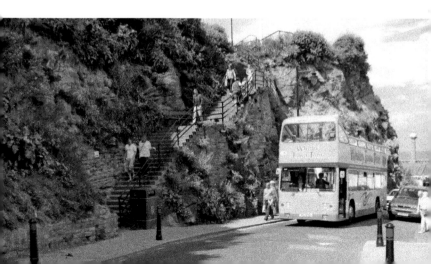

6. ENEMY SHIPPING

This captured German submarine *U-98* must have caused a sensation when put on display in the harbour for a week at the end of 1918, after hostilities had ceased. It was 247 feet long and was open to the public. There are no other vessels in sight – remarkable!

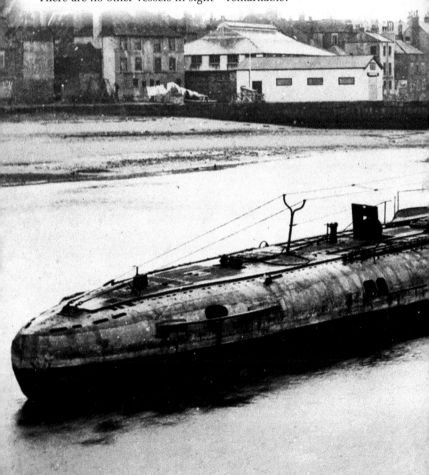

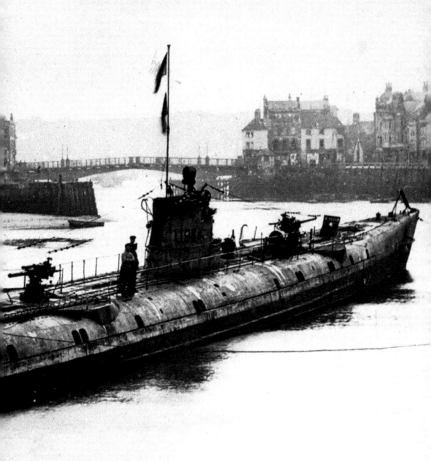

Ex-German Submarine U-98 in Whitby Harbour.—Length 247 feet.

7. A FISHERMEN'S STUDY BY J. T. ROSS

John Thomas Ross specialised in producing real photographic postcards of typical scenes in Whitby before the First World War. Taken around 1908, this view shows 'Whitby Fishermen Repairing Crabpots' by the harbourside. Full of atmosphere, such postcards represented the Facebook or Instagram of the period, with no radio, TV or even newspapers for ordinary folk.

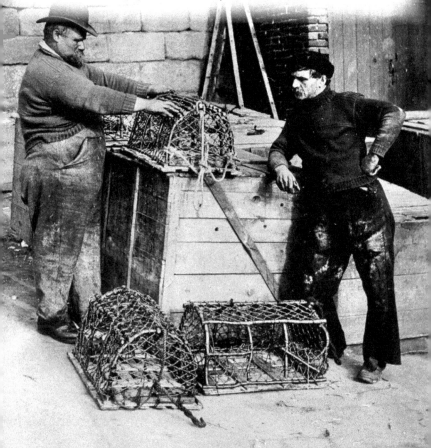

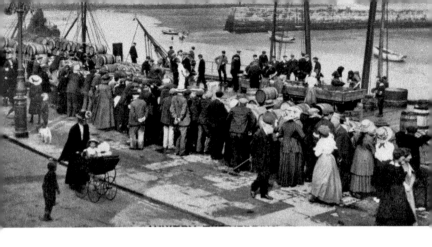

8. THE FISHING INDUSTRY

Herring fishing was a significant industry for the town for at least 150 years until the 1960s, when concerns arose about overfishing, particularly by foreign boats, and a complete ban was then introduced. Other subsequent restrictions have almost destroyed the trade, with some of Whitby's remaining fishing vessels operating away from the area.

9. 'GIPPING' HERRINGS

Taken just before the First World War – the new harbour bridge can just be seen in the distance – this postcard shows the Scottish herring girls on the Fish Quay. The herring shoals moved south across the Yorkshire coast in July and August, and the Scottish boats followed them, with a team of their own girls to gut the herrings and pack them tightly with salt into barrels for trade at home and abroad.

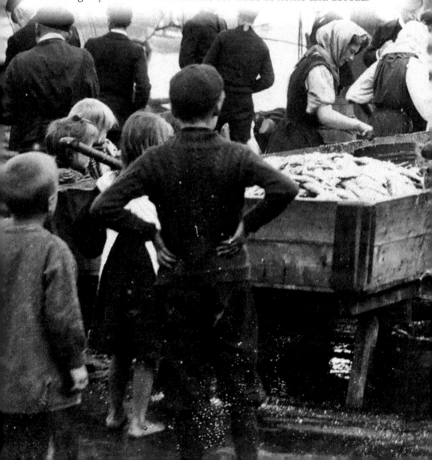

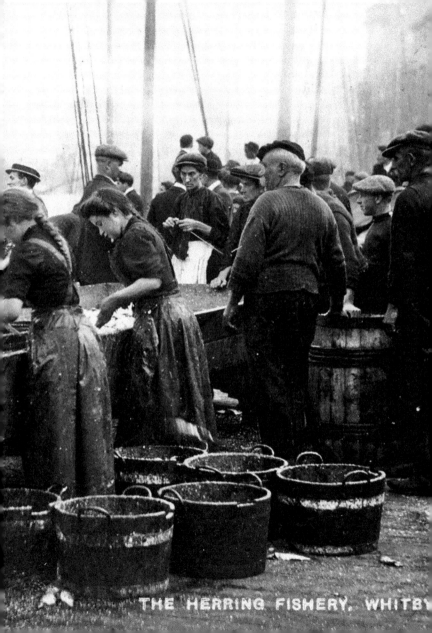

THE HERRING FISHERY, WHITBY

10. THE HERRING FLEET

Taken in the 1950s, this postcard gives some idea of the herring 'bonanza' just before it all fell apart due to overfishing. It was claimed that you could walk right across the harbour on the boat decks, with many of the vessels coming from romantic-sounding Scottish harbours like Anstruther, Pittenweem, and Stornoway. Some massive catches were achieved, and the herring were loaded into large fish boxes and placed on lorries. Sometimes there were too many and very large clamps of herring stood on the quayside waiting to go for processing as fishmeal.

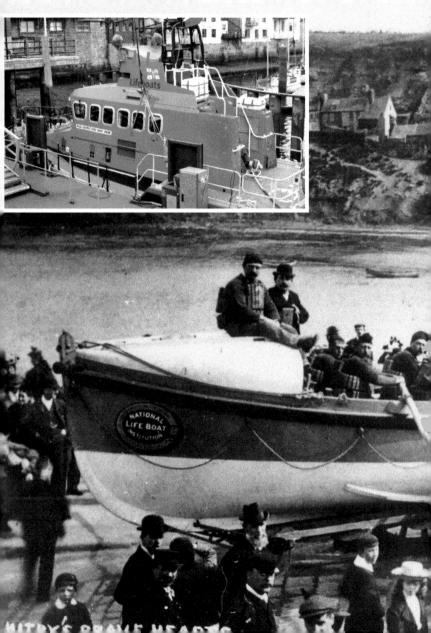

WITBY'S BRAVE HEARTS

11. THE ROWING LIFEBOAT

A harbourside view from around 1905 of the rowing lifeboat *John Fielden*. The volunteer crew are all wearing their cork life jackets. J. T. Ross entitled this view 'Whitby's Brave Hearts', capturing the courage required to face sometimes mountainous seas when rescuing survivors. Compare this to the powerful modern lifeboat (inset), although the serious challenges and risks are still there.

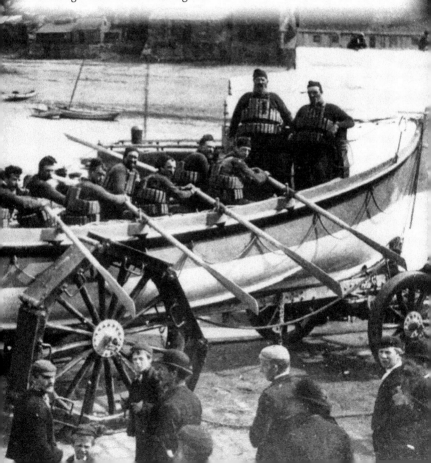

12. THE FIRST MOTOR LIFEBOAT

Against a backdrop of the old Market Hall and the Town Hall beyond it, the first motor lifeboat is welcomed on station in May 1919. This had been hastened by the appalling sinking of the *Rohilla* hospital ship outside the harbour in October 1914, when the contrasting performance of the local rowing lifeboat with the summoned Tynemouth motor lifeboat in heavy seas had convinced everyone of the need to modernise.

Inset: The *Mary Ann Hepworth* lifeboat (1938–74) now provides short sea cruises in a nostalgic acknowledgement of its proud past.

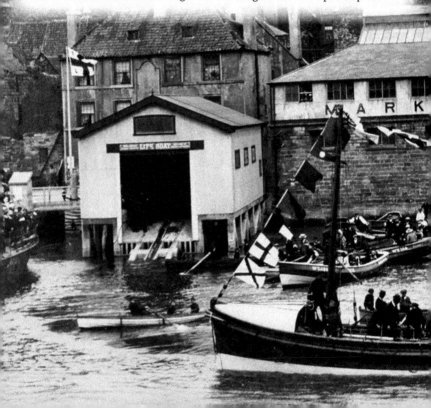

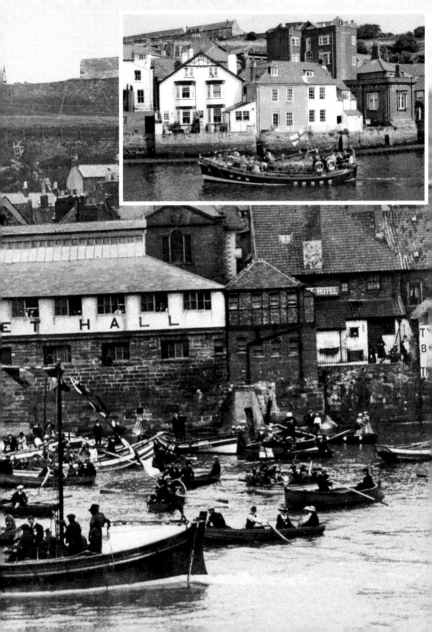

LITTLE FISHERMEN WHITBY

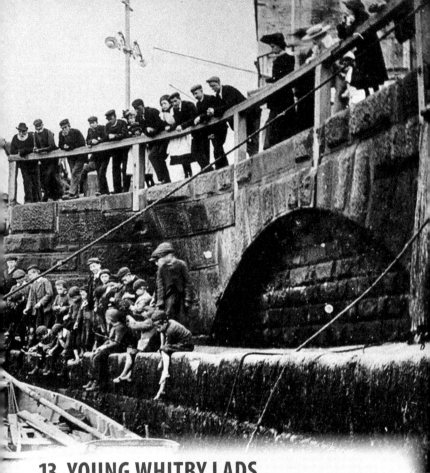

13. YOUNG WHITBY LADS

With the old bridge in the distance, a large group of young lads has gathered below the Marine Hotel at Coffee House End at the seaward end of St Anne's Staith. This is a postcard by J. T. Ross taken around 1905. Two traditional Whitby fishing cobbles enhance the scene, which has more appeal than the modern equivalent.

14. EARLY FISHING VESSELS

A Ross view in the lower harbour of the most common sail-driven local herring fishing vessels operating out of Whitby and Scarborough in the second half of the nineteenth century. Another illustration of the importance of the fishing industry to the town. Today there are still many masts in evidence, but most are essentially for a leisure experience that the fishermen of old never imagined or experienced.

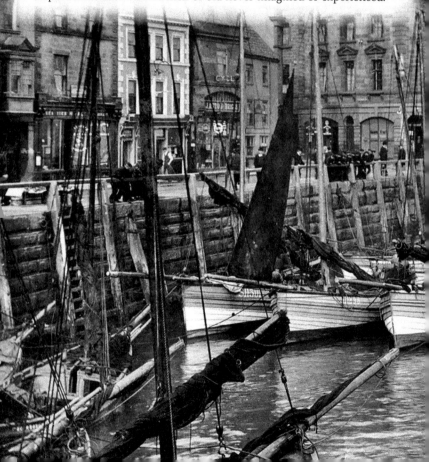

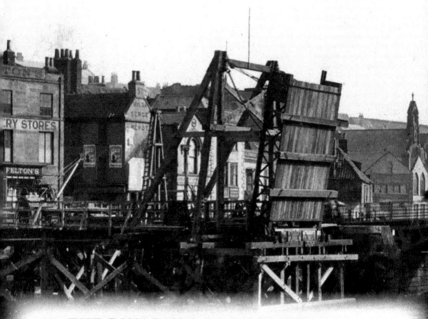

15. THE BUILDING OF THE NEW SWING BRIDGE

Capturing the temporary bridge structure in place in 1908/9, this view shows how contact between the east and west banks was essential to the life of the town. The old bridge, built in 1835 and seen in the background, was replaced by a new, much wider swing bridge, which opened in July 1909 and is still in place today. The change enabled much bigger vessels to pass to and from the upper harbour.

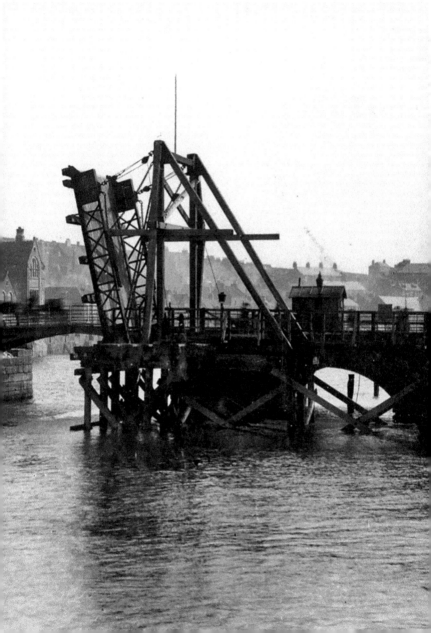

16. THE NEW BRIDGE OPENING CEREMONY

With the structure of the temporary bridge still evident, the excited crowds try out the new swing bridge on its opening day – 24 July 1909. Costing nearly £22,600, it was declared open by Mrs Gervase Beckett, the wife of the local MP. In more recent years there have been calls to further limit the weight of vehicles using it, particularly in the light of a series of mechanical failures.

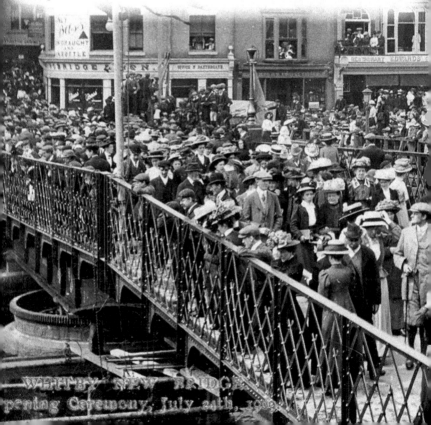

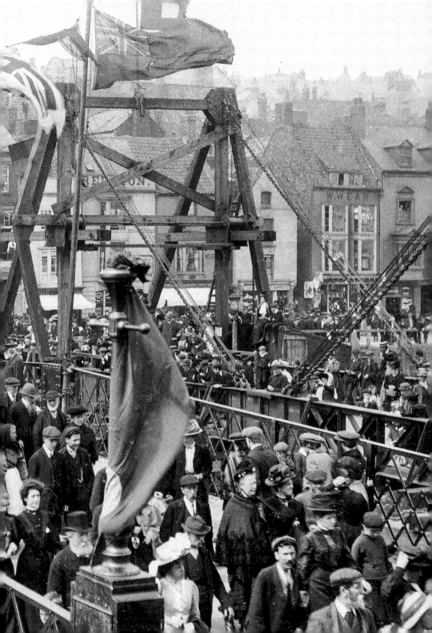

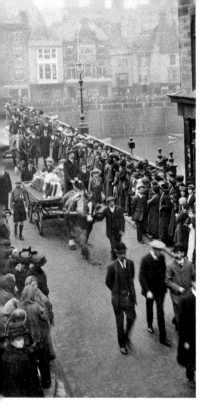

17. THE *ROHILLA* DISASTER

A mass funeral procession crosses the swing bridge, arising from the foundering in rough seas off Saltwick Nab of the hospital ship *Rohilla* on 30 October 1914. More than eighty of the 229 people on board lost their lives, even though valiant efforts were made to reach them. The procession to the Whitby cemetery initially involved ten of the victims, with an eventual total of thirty-three buried there. A commemorative memorial was erected to record this appalling tragedy.

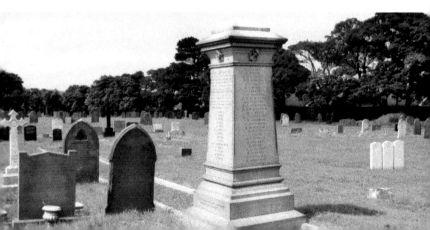

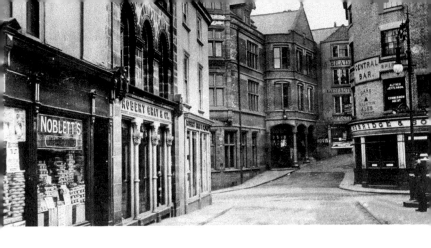

18. THE OLD MARKET PLACE

Taken in 1906 from the bridge, the Golden Lion Bank risies in the distance. The Central Bar on the right later became the Custom House. The property in the left foreground was demolished in 1974 to improve traffic movement in the bridge area. This was the site of the original Whitby Old Market Place before it moved in 1640 to the Old Town Hall area on the east side.

19. THE TEMPORARY BAILEY BRIDGE

Not many people remember the spectacular temporary pedestrian bridge built across the upper harbour in early 1955. Important maintenance work was required for the swing bridge, and it was essential to maintain access across the harbour, at least on foot. The Army provided a 'Bailey Bridge' from mid-January to mid-March. The high-level road bridge was not opened until March 1980.

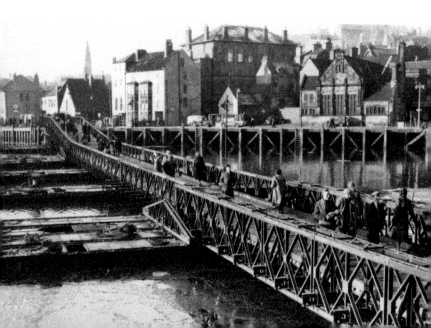

20. JOHNSON'S YARD

Whitby is famous for its yards, which enabled a much higher density of cheaper housing and afforded greater protection from bad weather. Johnson's Yard lies at No. 59 Baxtergate, and in some ways has changed little during the past century.

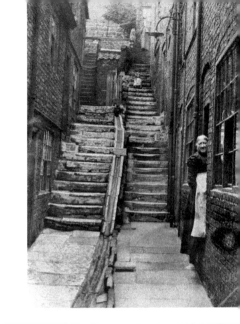

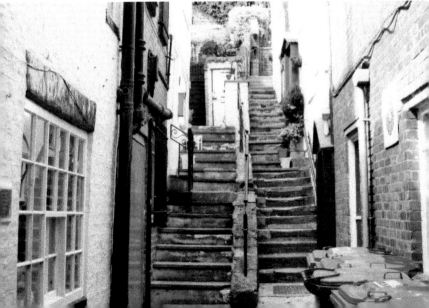

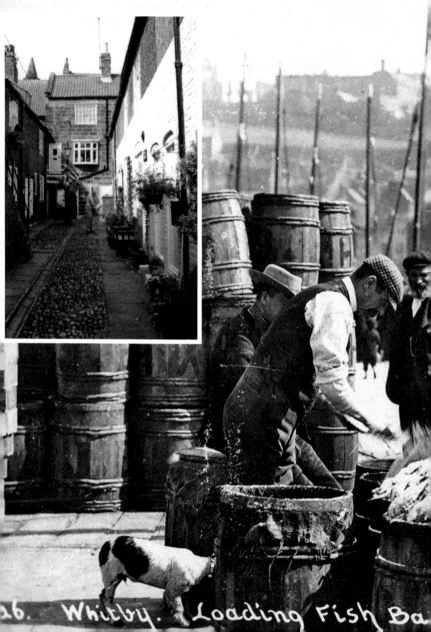

a6. Whitby. Loading Fish Ba

21. QUAYSIDE ACTIVITY

With the abbey area evident in the background on the East Cliff, this postcard view confirms that fish landing activities were not confined to the lower harbour. Taken at Dock End, near to the modern Trenchers Restaurant, the gutting, salting and packing of herring into wooden barrels dominates the harbourside. Today Linskill Square, one of Whitby's prettiest yards, can be found close by.

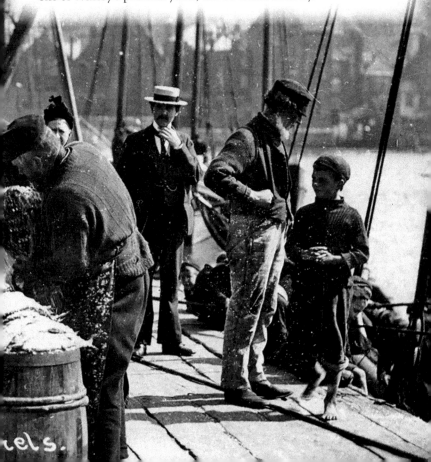

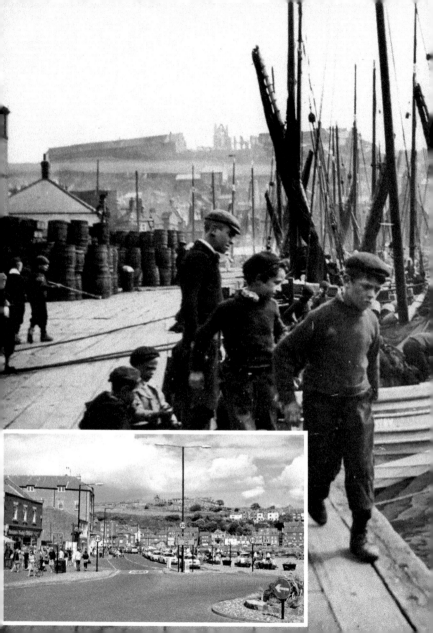

22. YOUTHFUL ADVENTURES

Also taken at Dock End, with large wooden herring barrels again evident in the left background, young boys watch the fishermen preparing their boats for the next sea trip. Taken around 1910, the harbour activities would fascinate the young children. The modernised area has now lost much of its original character and atmosphere.

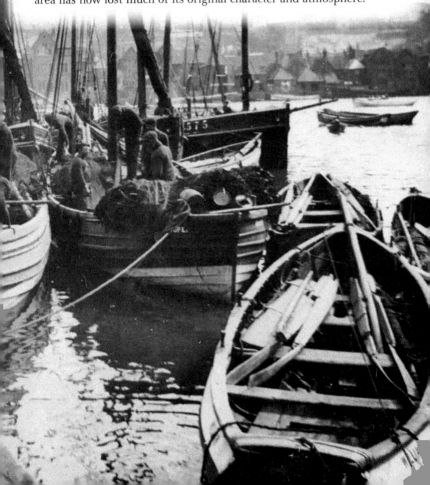

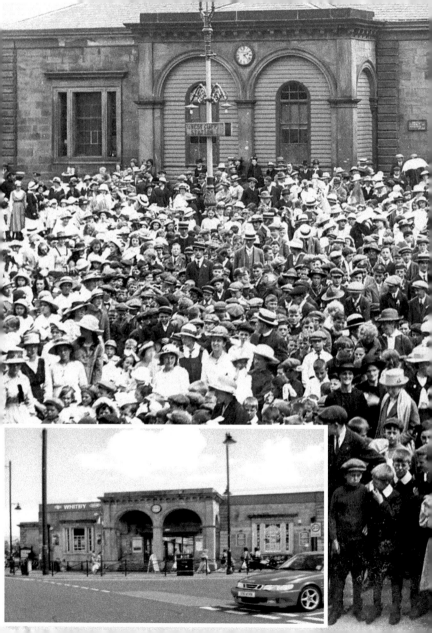

WHITBY

23. CHILDREN'S PEACE CELEBRATION

A fine view of several hundred Whitby children and their parents in front of the railway station, celebrating the end of the First World War. The date is 16 July 1919. At least 280 men from Whitby parish didn't return from the First World War.

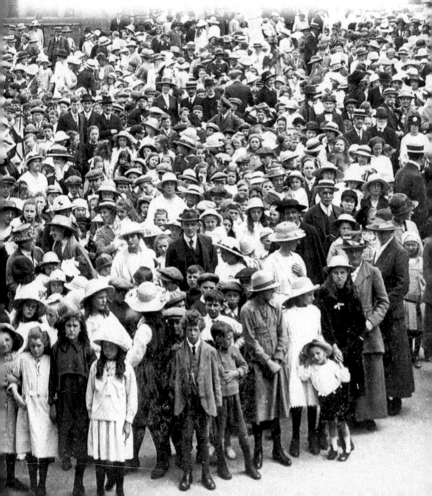

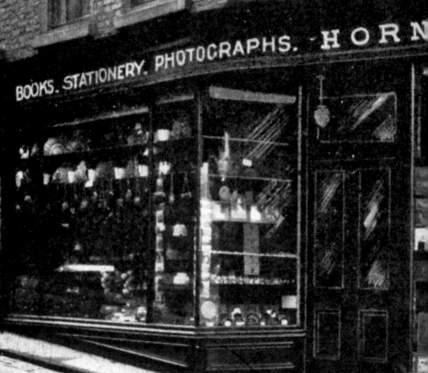

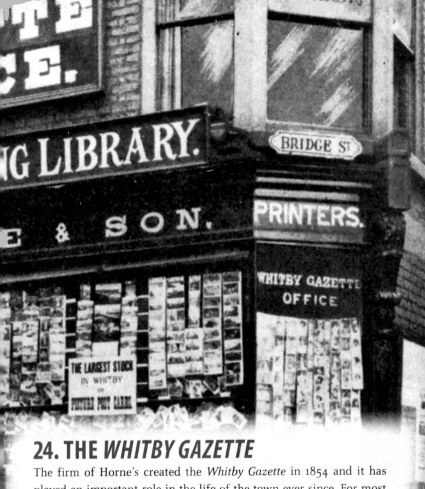

24. THE *WHITBY GAZETTE*

The firm of Horne's created the *Whitby Gazette* in 1854 and it has played an important role in the life of the town ever since. For most of its life it was based in Bridge Street, but has relocated to The Ropery in recent years. With so many developments in information technology, traditional newspapers are now struggling to maintain their circulations. The main image dates from around 1920.

25. CHURCH STREET

Perhaps the oldest thoroughfare in Whitby, there are records of Church Street as early as 1318. Inevitably, it was built for a much more limited traffic flow. In modern times it has been widened – with the sad demolition of some interesting and ancient properties – around 1936 and again in the mid-1950s. Grape Lane runs off to the left in the foreground of the early image – a Ross postcard dating from around 1905.

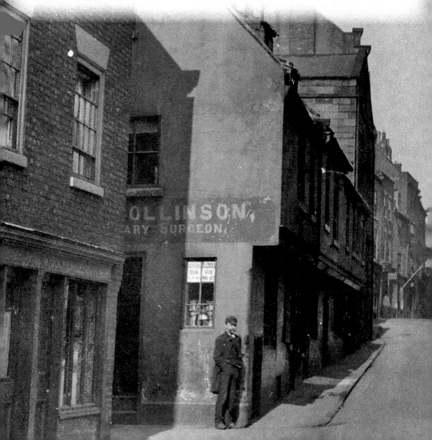

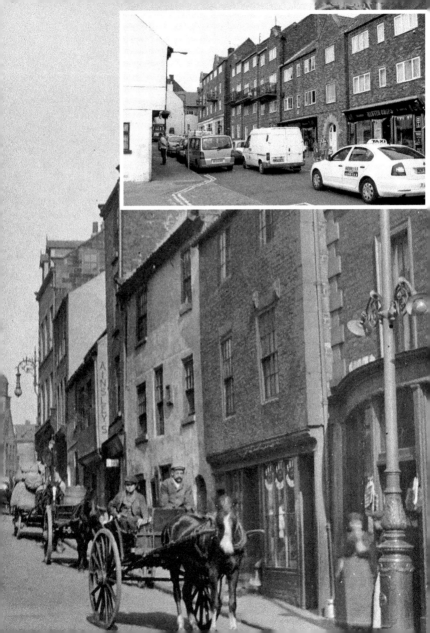

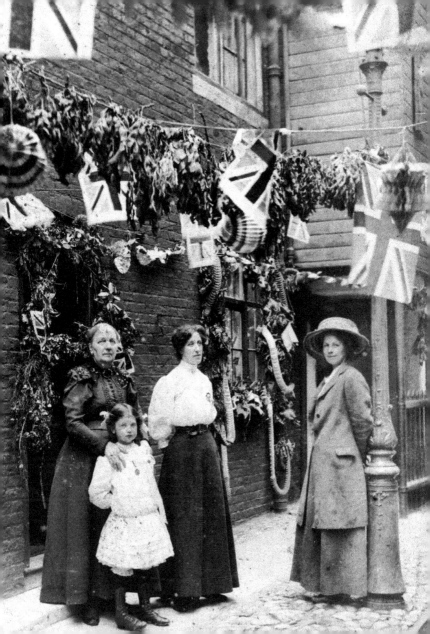

26. PEACE CELEBRATIONS, 19 JULY 1919

Another two more views in Church Street at around the same standpoint. A marching column of service men is passing the end of Grape Lane in the direction of the shipyards. Flags are much in evidence and the children are excited by the occasion. The bigger image by J. T. Ross shows a family celebration at the ending of hostilities in November 1918.

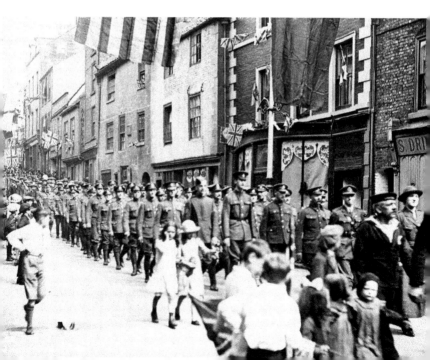

27. EARLY HOUSING AT BOULBY BANK

On the hillside above Church Street, these galleried houses cling to the steep contours. This is an iconic and famous Ross postcard from before the First World War illustrating the homes of some twenty local families. Sadly, these were finally demolished in 1958 and replaced by less spectacular accommodation.

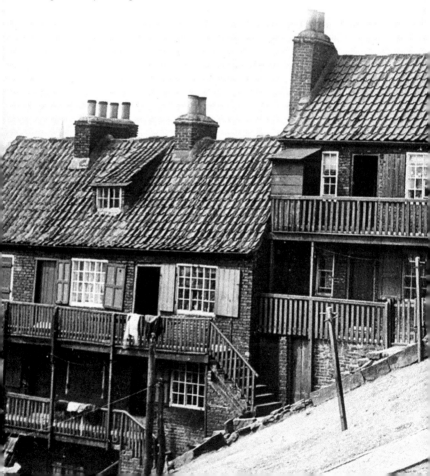

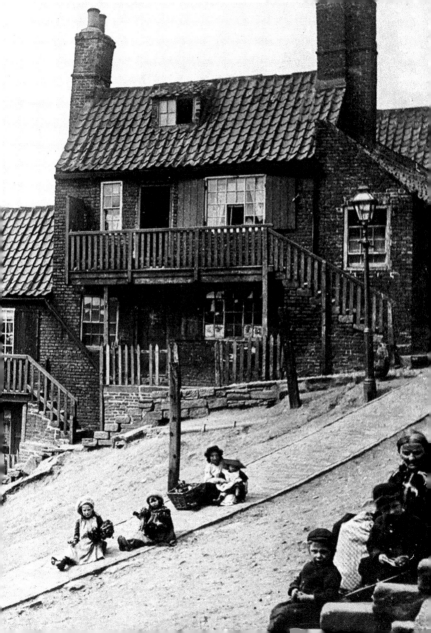

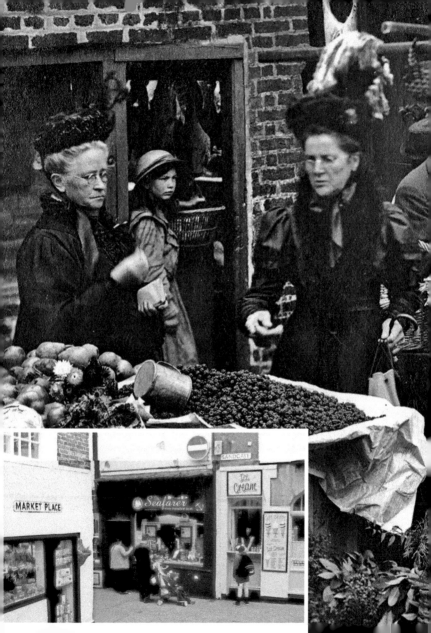

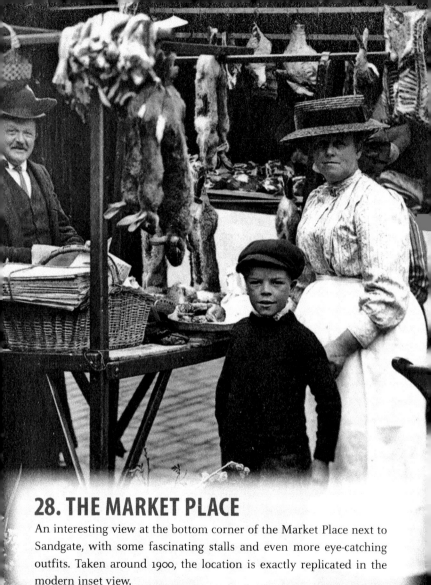

28. THE MARKET PLACE

An interesting view at the bottom corner of the Market Place next to Sandgate, with some fascinating stalls and even more eye-catching outfits. Taken around 1900, the location is exactly replicated in the modern inset view.

29. MARKET PLACE WITH TOWN HALL

The Town Hall was built in 1788, paid for by the Lord of the Manor Nathaniel Cholmley and constructed by Jonathan Pickernell. The building on the left is believed to be one of the oldest in Whitby.

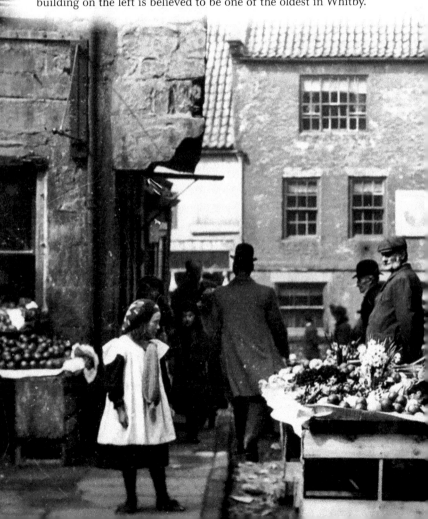

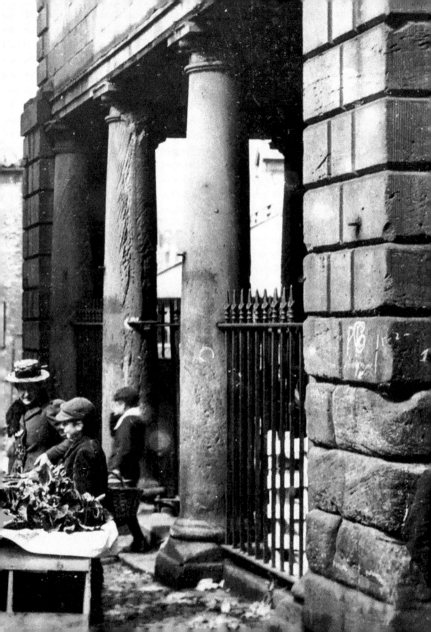

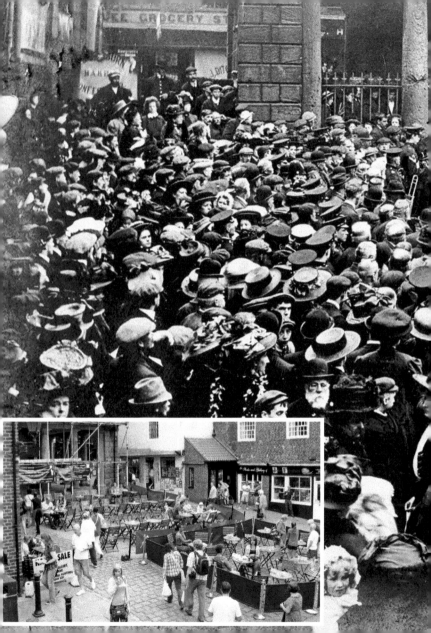

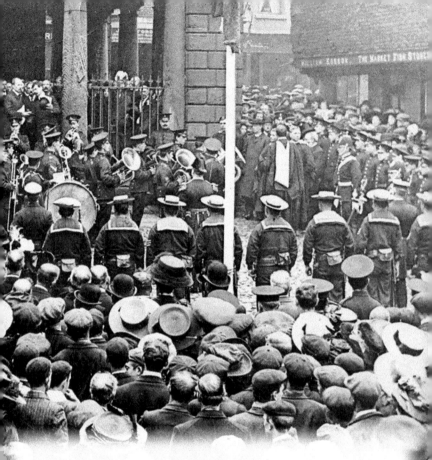

30. GEORGE V's PROCLAMATION, 1910

Edward VII died on 6 May 1910 and the customary public proclamation of a new monarch, George V, immediately took place, with the coronation following in 1911. With the Town Hall in the background, a military band, soldiers and marines add ceremony to the occasion. Market stalls still appear here regularly, but sometimes enterprising caterers provide a café culture for the Market Place in the summer months.

31. ARGUMENT'S YARD

Probably the most famous of Whitby's yards, Argument's Yard lies off Church Street and is named after a prominent local family who owned most of the beach bathing machines around 1900. At times the yard was clearly in need of serious refurbishment, but today it is a fairly chic and fashionable address.

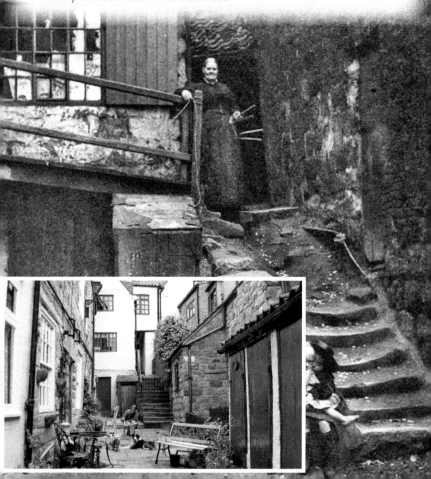

32. UNEXPECTED VISITOR

On the sands between Tate Hill Pier and the East Pier the *Daily Mail* promotional seaplane can be seen. It landed at Whitby and Scarborough at Whitsuntide in 1914, just before the outbreak of war. It must have been a spectacular event, particularly for the children, creating a public relations coup for the newspaper.

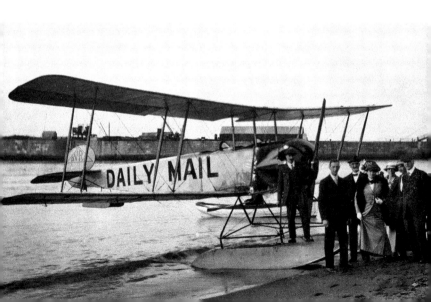

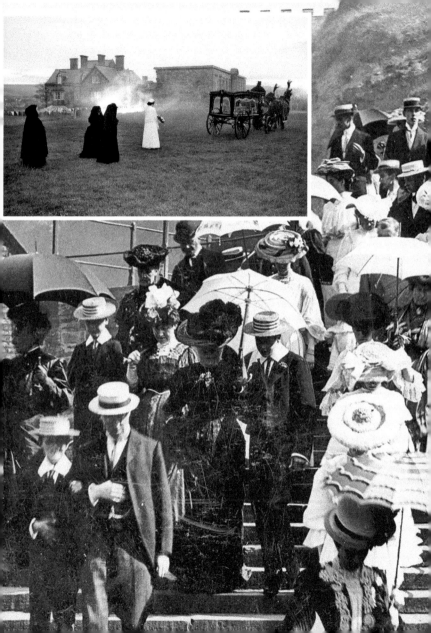

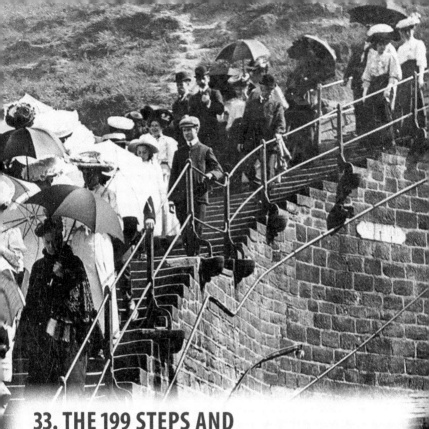

33. THE 199 STEPS AND
THE DONKEY ROAD

Capturing the fashions of the Edwardian age, this Sunday morning
congregation leaving St Mary's Church on the East Cliff negotiate the
famous 199 steps to arrive back in the town after morning service. To
the right lies the ancient 'donkey road' up to the abbey and church.
An atmospheric 'Goth' procession can be seen in the abbey grounds.
Many thousands of their followers come to special weekends in April
and October.

34. HENRIETTA STREET

Another of Whitby's very old streets, it was renamed 'Henrietta' in 1761 in tribute to the second wife of the Lord of the Manor, Nathaniel Cholmley. In 1787 a cliff collapse here made 196 families homeless. Fortune's kipper smoking house was established here in 1872. John Stephenson, the Whitby town crier, was a very familiar figure in the town, here seen advertising the *Whitby Gazette*. He died in 1907. He carries his bell under his arm.

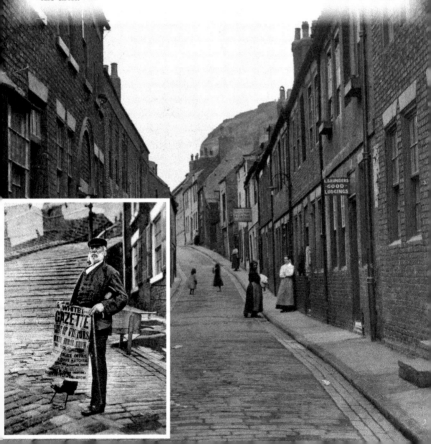

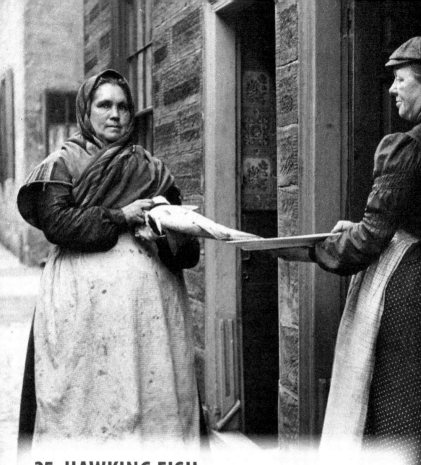

35. HAWKING FISH

The lady on the left selling fresh fish to a housewife in Henrietta Street was Dolly Gaines, wrapped up well in her usual work clothes on a cold morning and needing to pose rather formally because of the limitations of the cameras of the time. This is another Ross postcard from around 1905.

36. SOUTH AFRICAN WAR MEMORIAL, 1904

A large crowd has gathered at St Mary's Church on the East Cliff to witness the unveiling of a memorial to the eight local men who lost their lives in the Boer Wars. The ceremony took place on 16 September 1904, and the memorial can still be seen set into the internal wall of the church porch. The church and its grounds include many important historic features of early Whitby.

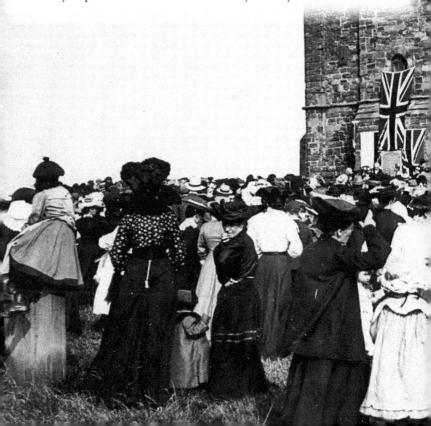

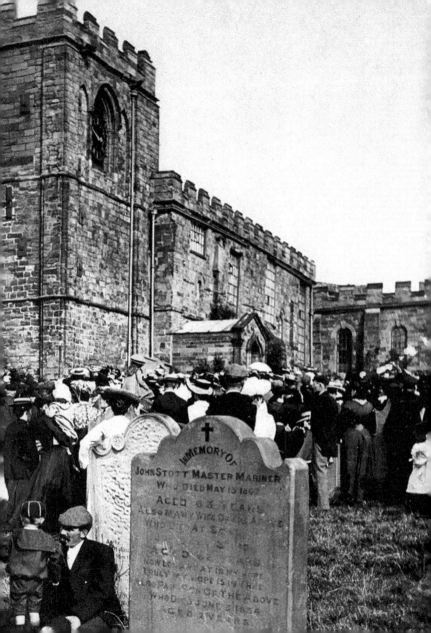

IN MEMORY OF
JOHN STOTT MASTER MARINER
WHO DIED MAY 15 1867
AGED 55 YEARS
ALSO MARY WIFE OF THE ABOVE
WHO DIED AT SEA

NOW LORD WHAT IS MY HOPE
TRULY MY HOPE IS IN THEE
ALSO DAUGHTER OF THE ABOVE
WHO DIED JUNE 5 1854
AGED 2 YEARS

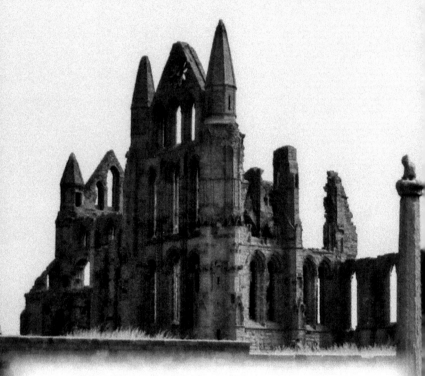

37. WHITBY ABBEY AND ANCIENT CROSS

The original monastery was built by Abbess Hilda in AD 657 and became the burial ground of the Northumbrian royal house. A new abbey was constructed in 1078, but the present remains date from around 1220 and took more than a century to complete. The main tower fell in 1830. The abbey cross dates from the fourteenth century. The early postcard (inset) is dated 1913.

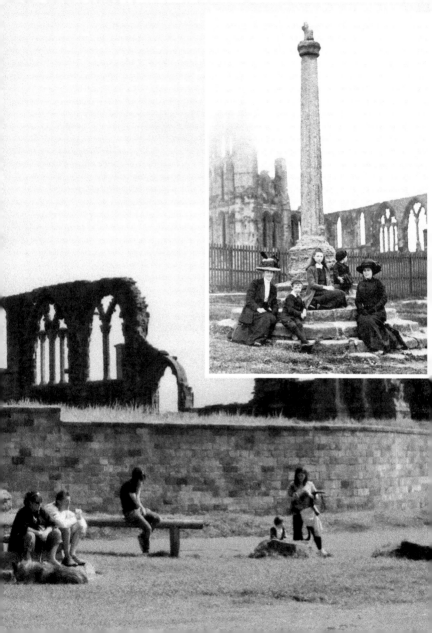

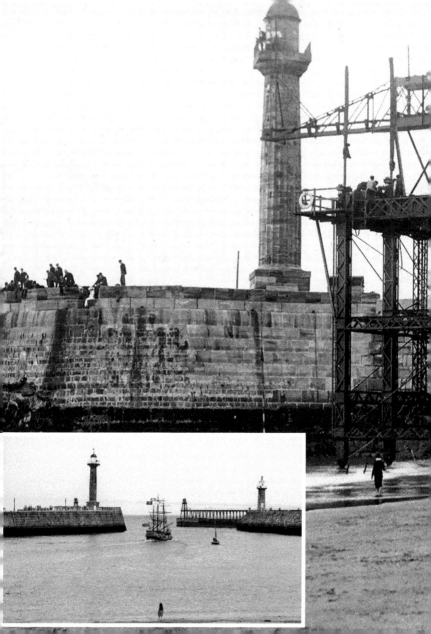

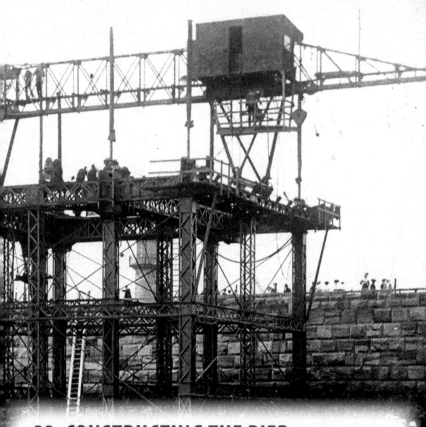

38. CONSTRUCTING THE PIER EXTENSIONS

The pier extensions were constructed in the period 1909–14 and involved specialised equipment to withstand tides, weather and underwater conditions. It was a formidable challenge, and on occasions the 'walking men' at the east and west piers were partially collapsed by stormy seas. Urgent repair work on the piers and their extensions is now required, and it will be expensive.

39. THE COMPLETED PIER EXTENSIONS

The new pier extensions created a huge and very favourable impression. They afforded much greater protection to the harbour and its shipping, helped to reduce the accumulation of sand at the harbour entrance, and offered a very pleasant walk for the residents and visitors on their completion in the early months of 1914.

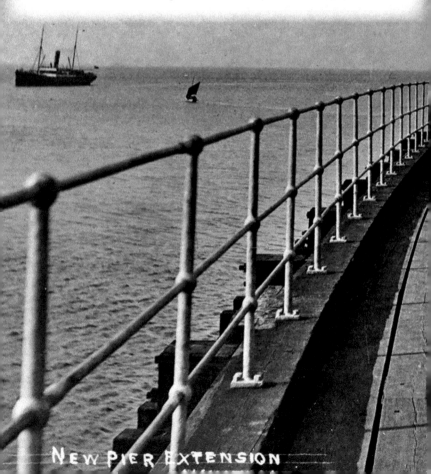

NEW PIER EXTENSION

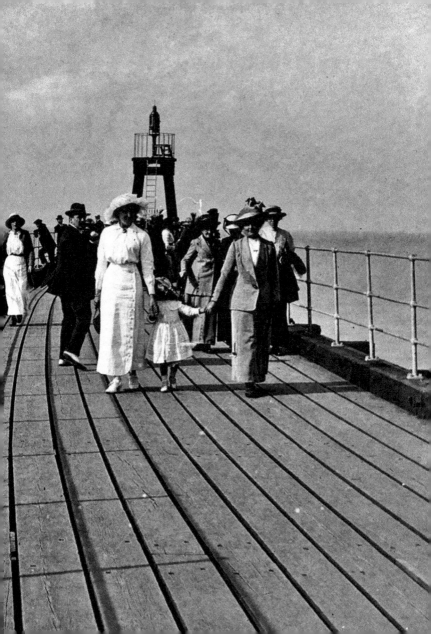

40. DONKEY RIDES ON THE BEACH

A postcard view from 1925 of several donkeys offering their traditional service on Whitby beach. The origin of this custom is evidently lost in the mists of time, but must go back some 200 years at least. The tradition is still maintained today.

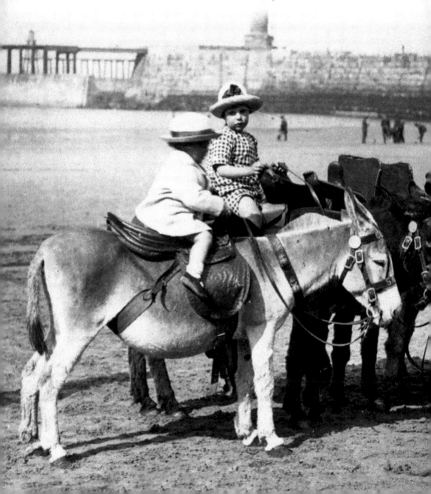

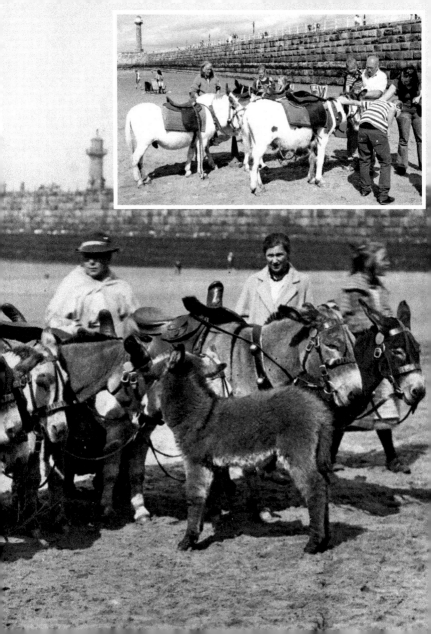

41. SEA BATHING

Posted in August in 1905, this Ross postcard brilliantly captures the age of the bathing machine. Most of them were owned by a local family firm by the name of Argument. When the customer was on board, they were drawn out into the deeper water. The bathers changed inside, having paid their 6d for a half hour's experience, and entered the water from the front steps. Men and women had separate sections of the beach for this activity, in order to avoid too much excitement. Note the lovely Edwardian outfits – probably too overdressed for the sands by our way of modern thinking!

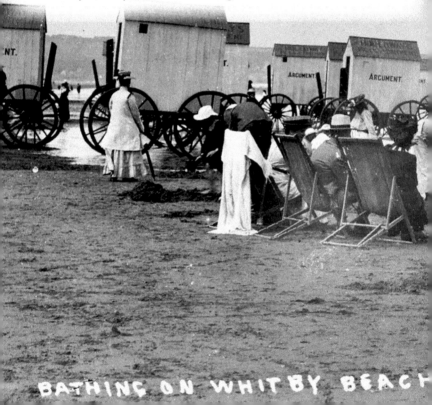

BATHING ON WHITBY BEACH

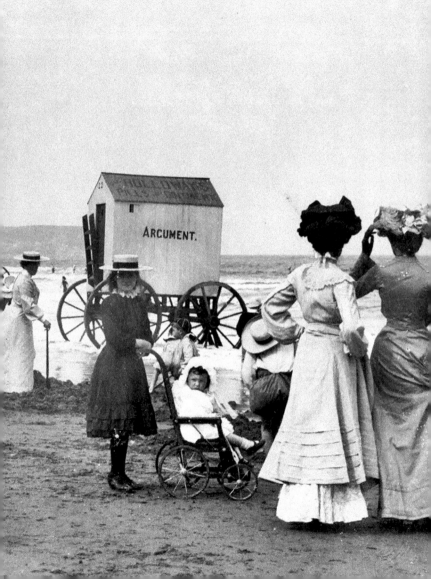

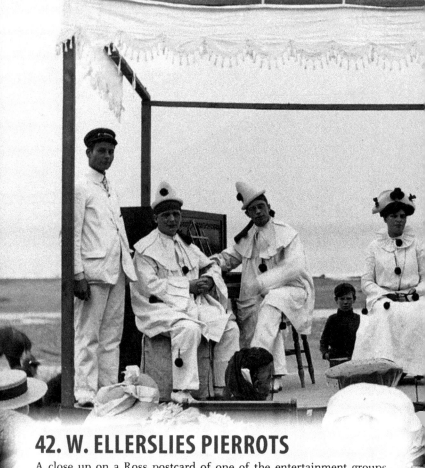

42. W. ELLERSLIES PIERROTS

A close up on a Ross postcard of one of the entertainment groups on Whitby beach around 1910. Many of the Yorkshire seaside resorts featured a Pierrot troupe in the years before the First World War. Music, singing, dancing and comedians featured, and traditionally the performers wore the 'pompoms and ruffles' outfits seen here. It was a very popular activity, and, amazingly, usually involved the transportation of a piano to the beach!

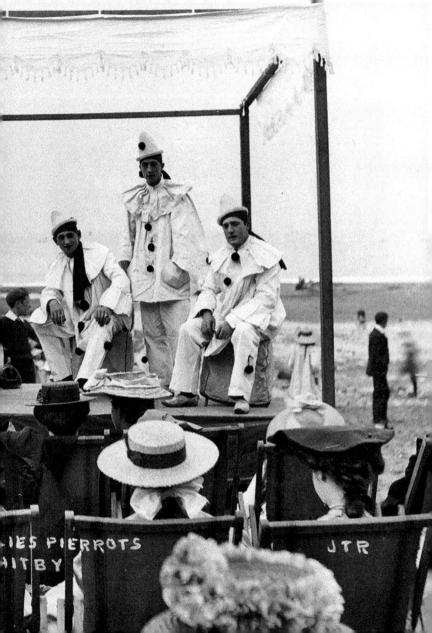

43. OUTSIDE THE ROYAL HOTEL, WEST CLIFF

A splendid view of four horses drawing an open carriage on the road outside the Royal Hotel around 1905, a very pleasant way to enjoy the Whitby scene. The abbey is just visible on the left in the distance. An alternative form of pedal-operated transport is illustrated, but the modern version requires more passenger effort!

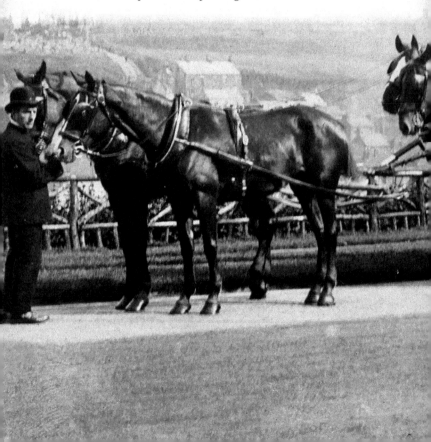

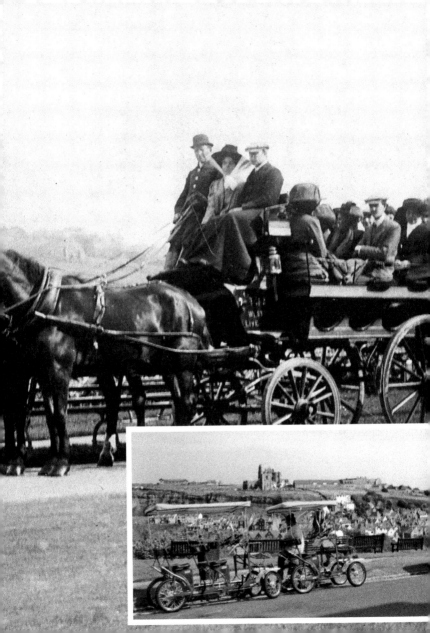

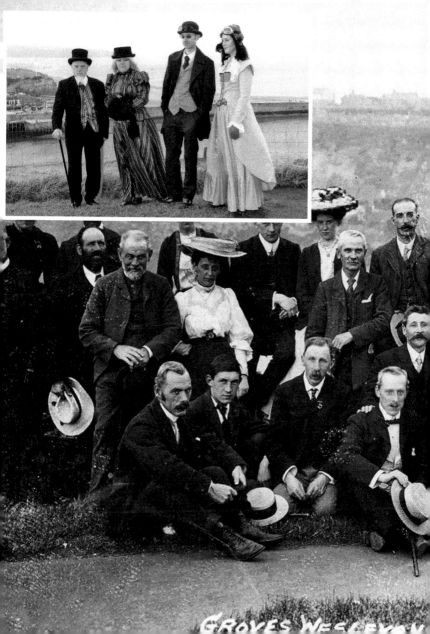

GROVES WESLEYAN

44. FASHION PARADE

A well-known visiting choir – the Groves Wesleyan – poses at the same place, across the road from the Royal Hotel, on 5 July 1905. The abbey lies in the distance, fortunately not obscured by the array of large hats worn by the lady singers! Contrast their outfits with those of a group of modern Goth visitors pictured on the opposite cliff (inset) – a strange mixture of the authentic with the bizarre!

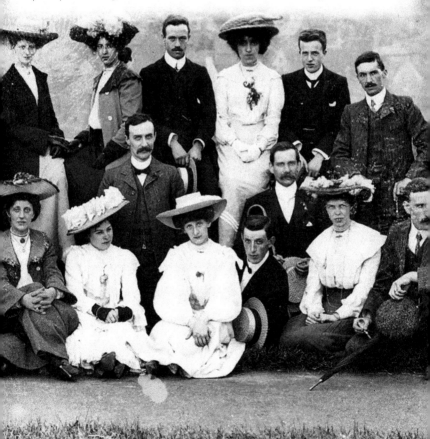

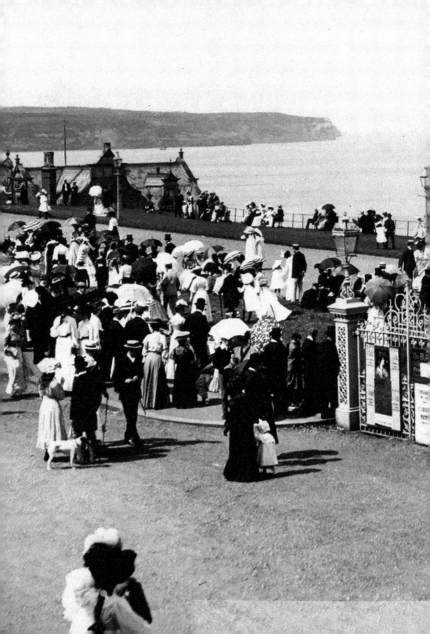

45. WEST CLIFF PROMENADE

Some beautiful fashions on view near the Royal Hotel, with the roofs of the spa building below the clifftop on the left. Taken around 1905, it shows how much most people cared about their appearance when out in public – no anoraks or trainers here! Most of these early visitors would have arrived on the railway.

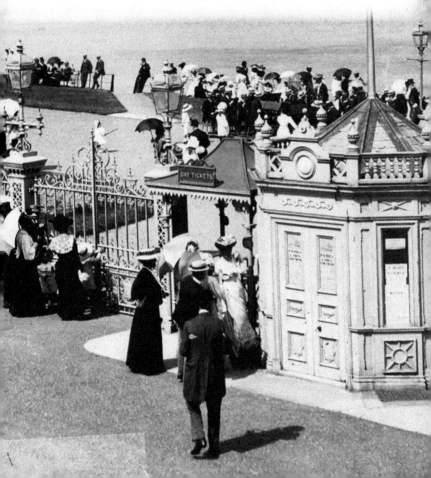

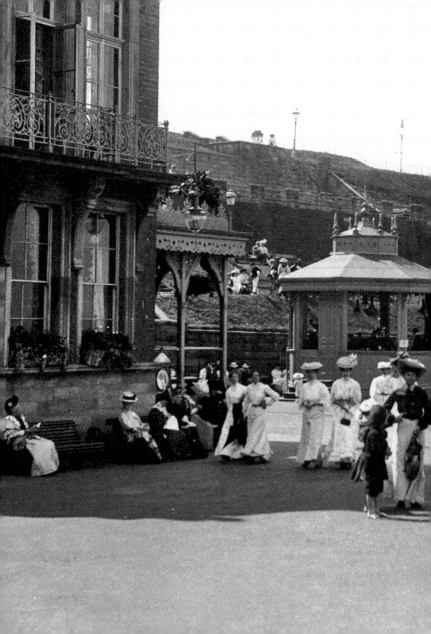

46. WHITBY SPA

In this image from around 1908, the spa building lies on the left, but the rest of the site has since been much modified over the intervening years. Elegance is again in evidence. In the right-hand distance is the Hotel Metropole, on top of the West Cliff.

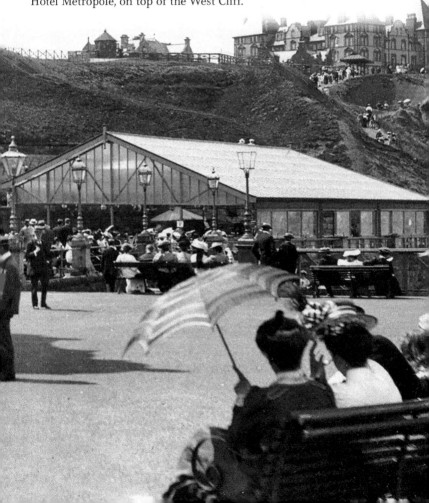

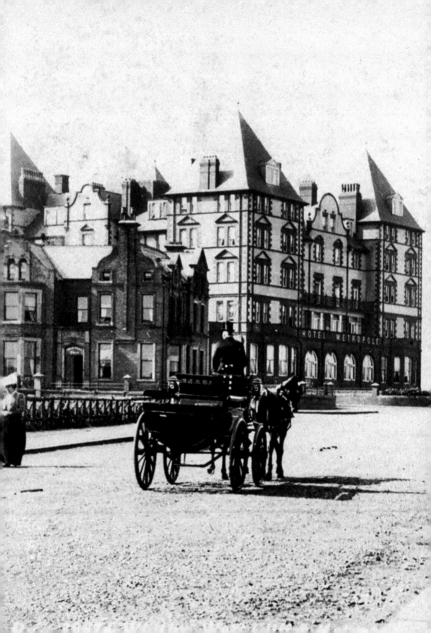

47. HOTEL METROPOLE

This imposing building opened in 1898, and in 1902 it became one of the first to have a public electricity supply. It was regarded as a prestigious establishment and used for important events in the town. The postcard dates from 1908, and the elegant weather shelters on the right have been restored in 2017 after being flattened by high winds.

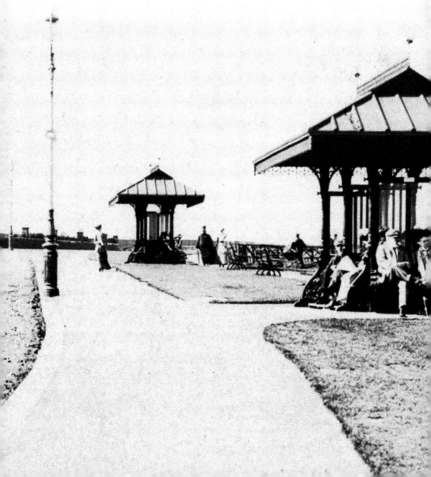

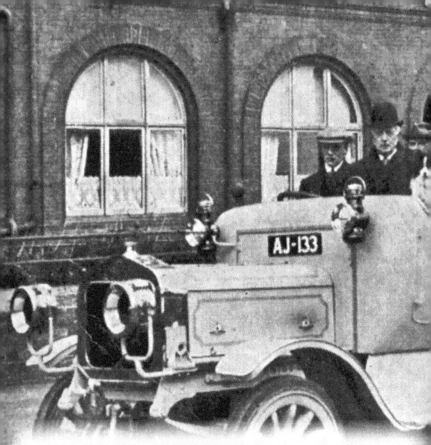

48. TRANSPORT THROUGH THE AGES

An advertising postcard from 1913, taken in front of the Hotel
Metropole, for the charabanc hire service operated by Mr Barker of
the Royal Hotel Stables Garage. A very early vehicle registration can
be noted. Until recently a restored Sentinel steam bus – *Elizabeth* –
gave visitors an exciting and noisy ride around the town from near
the harbourside bandstand, but after several years in operation it has
now sadly disappeared.

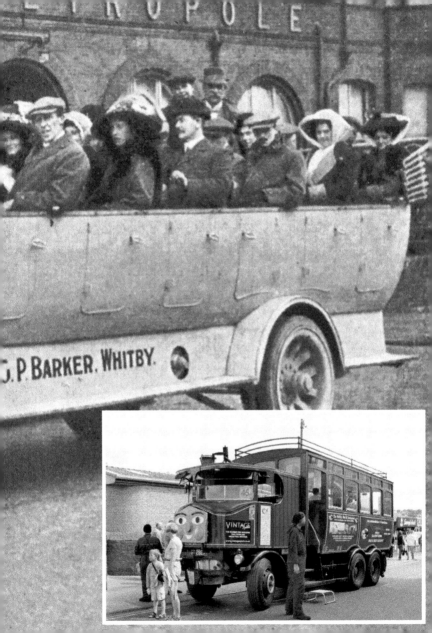

G. P. BARKER. WHITBY.

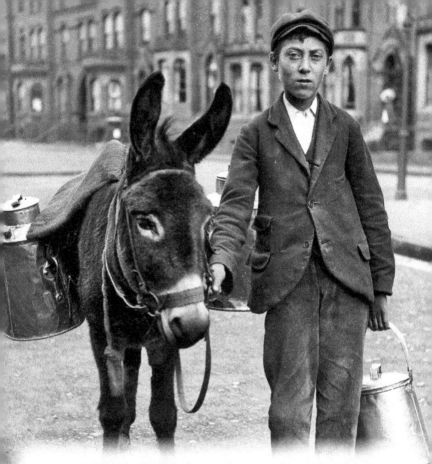

49. THE MILK SELLER

A very famous character study by Ross of a familiar street scene before the First World War. A working donkey carries the fresh milk in small churns. The milk would be poured or ladled into your jug on the front doorstep. The terrace of houses in the background is part of Church Square, which is dominated by St Hilda's Church.

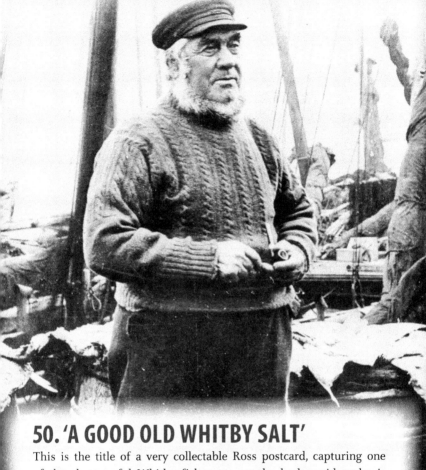

50. 'A GOOD OLD WHITBY SALT'

This is the title of a very collectable Ross postcard, capturing one of the characterful Whitby fishermen on the harbourside, who is standing next to some of the herring barrels, around 1905. Believed to be called Corey Gaskin, he is dressed in the traditional seafarer's 'gansey' or jersey, of which many patterns existed, knitted by the wives and often including the initials of the wearer in case they perished at sea.

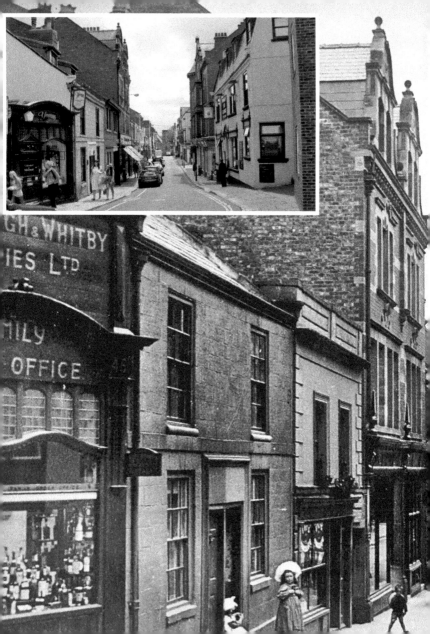

51. SKINNER STREET

Another Ross postcard from around 1905, showing Skinner Street with the Trinity Presbyterian (now United Reformed) Church at the top of Flowergate in the distance. The street dates back to 1762, and was named after a John Skinner. Frank Sutcliffe had a studio here, and Elizabeth Botham first opened her bakery premises in the 1880s. The present shop and upstairs restaurant date from 1926.

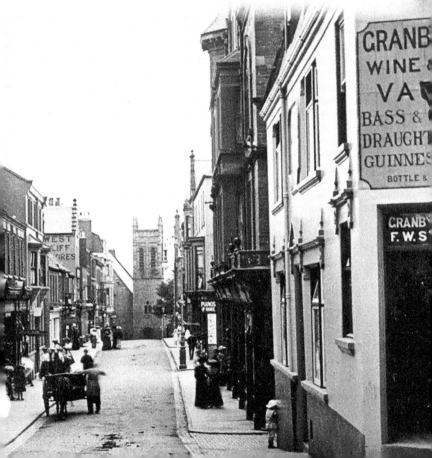

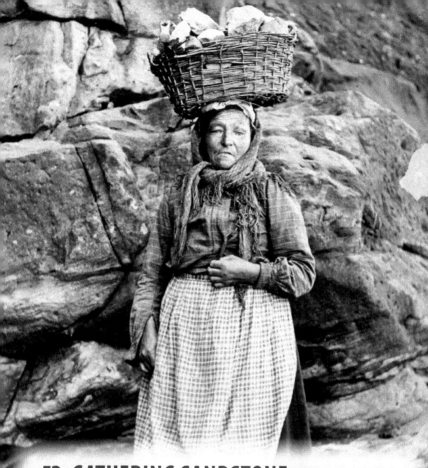

52. GATHERING SANDSTONE

The caption on the postcard reads 'Sand, Any Sand – Whitby Hawker'. Taken on the beach around 1905, this shows an older lady – Mary Arnold – offering for sale lumps of soft sandstone that she has gathered. This was used as so-called 'donkey stone' or 'scouring stone' to householders who would rub it on to their stone doorsteps to freshen up their appearance.